illustration school:
let's draw magical color

sachiko umoto

Quarry Books
100 Cummings Center, Suite 406L
Beverly, MA 01915

quarrybooks.com • craftside.typepad.com

First published in the United States of America in 2014 by
Quarry Books, a member of
Quayside Publishing Group
100 Cummings Center
Suite 406-L
Beverly, Massachusetts 01915-6101
Telephone: (978) 282-9590
Fax: (978) 283-2742
www.quarrybooks.com
Visit www.Craftside.Typepad.com for a behind-the-scenes peek at our crafty world!

Library of Congress Cataloging-in-Publication Data available

ISBN: 978-1-59253-917-8

10 9 8 7 6 5 4 3 2 1

Printed in China

dear reader

Don't you feel happy when you find a lovely color?
Lots of yummy-looking colors in a cake shop.
Fancy colors that fashion models wear.
Cool and eye-catching colors on posters that you find plastered throughout town.
Wouldn't it be nice if you could use such colors in your works?

To tell you the truth, I was very bad at using colors.
Even when I painted the color boldly thinking that it would be beautiful, the picture
ended up looking unsophisticated...
So, I decided to observe each color and become friends with each of them.

Recently, I have begun to understand that there are many kinds
of emotions hidden inside colors.
A beautiful way to use colors is to find a suitable
emotion that matches the mood and by
doing so, delivering your message to people.

You can state your opinion, such as "I like this color!"
But, it is also important to listen to the voice of
colors. Some colors will say, "This is my mood.
This is what I'm good at." Let's become friends
with them little by little.

There is no need to paint a color exactly the same
as the examples in this book. Your imagination
will no doubt be a little different from mine.
Please turn the world of white paper into an exciting
place with your magical power of color.

Sachiko Umoto

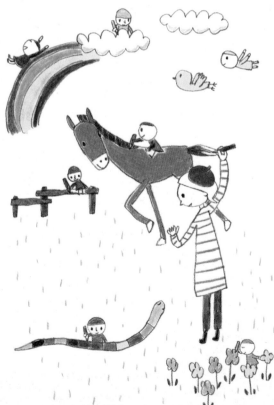

how to read this book

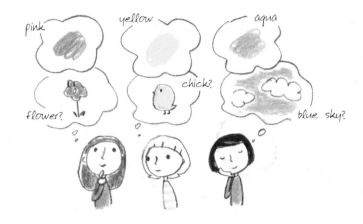

1 choose the color

Find an illustration that you like and find a color that you want to use. Ask your family or friends what kind of color they like.

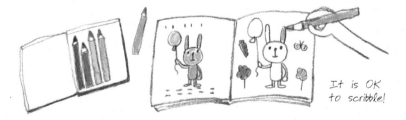

It is OK to scribble!

2 emulate

Enjoy coloring as your mood dictates by using the page on the left as a reference.

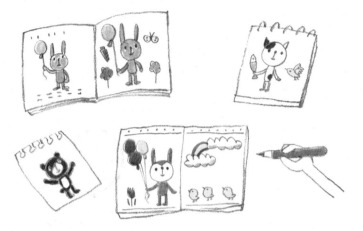

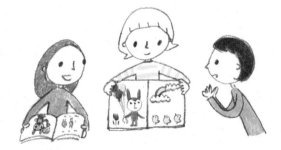

3 change

Copy somebody's illustration by just drawing a picture on a notebook or on a piece of paper. Try drawing it using different colors.

4 show it

Show your favorite illustration to your family or friends.

tools for coloring and how to use them

It is difficult to know which coloring tool to use, since there are so many of them.

Let's try them out one by one, starting with the tool you already have.

In this book, we will use a set of twelve colored pencils.

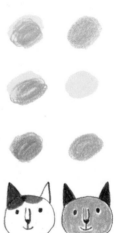

👑 *Recommended!*

Colored Pencil

You can get a warm, gentle finish using them. You can produce a faint color if you color with it gently, or you can produce a thick color if you color with it firmly. It is also beautiful to layer various colors.

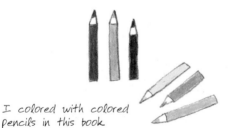

I colored with colored pencils in this book

♔ *Recommended!*

Coupy-Pencil

The feel of this pencil is something between a colored pencil and a crayon. The color is bright and you can erase it using an eraser. Because you can color evenly using this pencil, it is easy to color a large area.

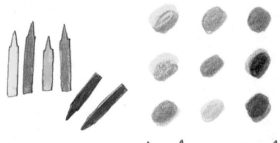

The color is bright.

Watercolors

The way they bleed is very beautiful. You can dissolve them with water even after they dry out. You can draw a precise line if you layer the color after the first color is dry.

Wait until the first color dries

Layer the second color on top of the first color before it dries.

Acrylics

They produce a strong color and never dissolve in water once they dry. You can draw both thin and thick lines. There are transparent watercolors and nontransparent watercolors depending on the maker.

Polishing paste

Modeling paste Matting paste

Use a paper palette because acrylic paints get hard once they have dried.

Transparent Nontransparent

You can give your illustration texture

The bottom color can be seen transparently if you layer the colors.

Markers

You can draw cheerful pictures because they produce bright colors. The way the ink bleeds is interesting. Be careful when coloring with them because they often bleed through a sheet of paper.

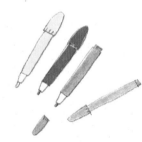

Colored Ballpoint Pen

It is fun to layer thin lines using various colors. The direction in which you move your hand is going to be the shape of the line. Try drawing many lines so that you can find new ways of coloring.

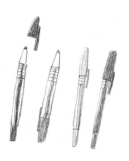

Dots

Horizontal and vertical lines

Tight scribble

Loose scribble

Concentrated scribble

Crayons

Their thick and gentle lines give a warm expression. They are not good for producing delicate expressions. It is good to use them on big sheets of paper so that you can color freely.

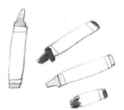

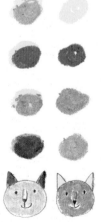

contents

mina the color wizard

Once upon a time, the world was made of black and white.

I thought it was an apple, but it was a pear!

Oops! I ate the laughing mushroom!

I'm all right with black and white.

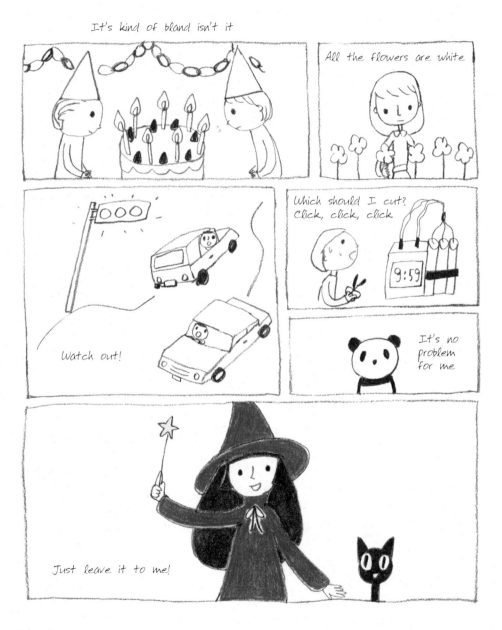

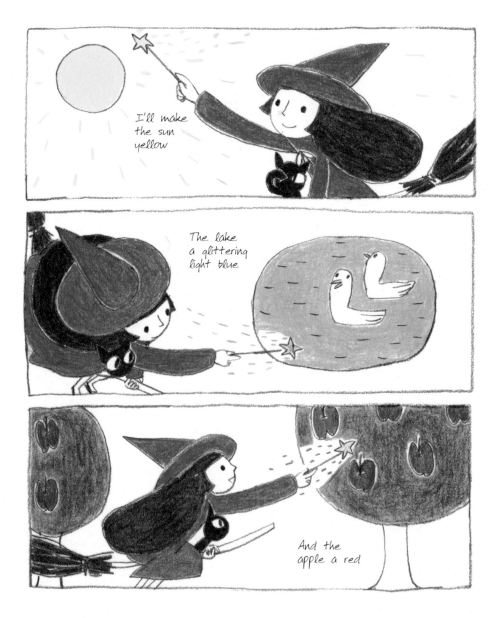

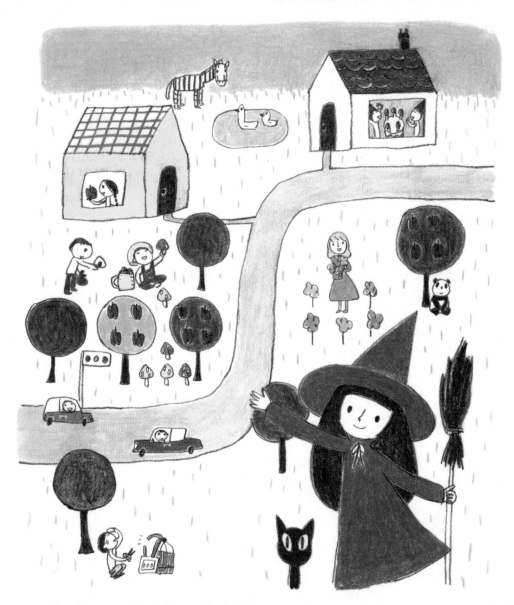

See how wonderful the world looks!

CHAPTER 1
color is magical

color is magical!?

If you color an empty cup...it looks like there is juice inside.

You can make as many kinds of juices as the number of colors you have.

Is it a sweet juice? Or is it a sour juice?

Just by coloring a certain shape, your imagination is stimulated.

The impression of the illustration is going to be totally different if you color it with a different color.

In this chapter, let's enjoy using many kinds of colors as if you are using a "magical power."

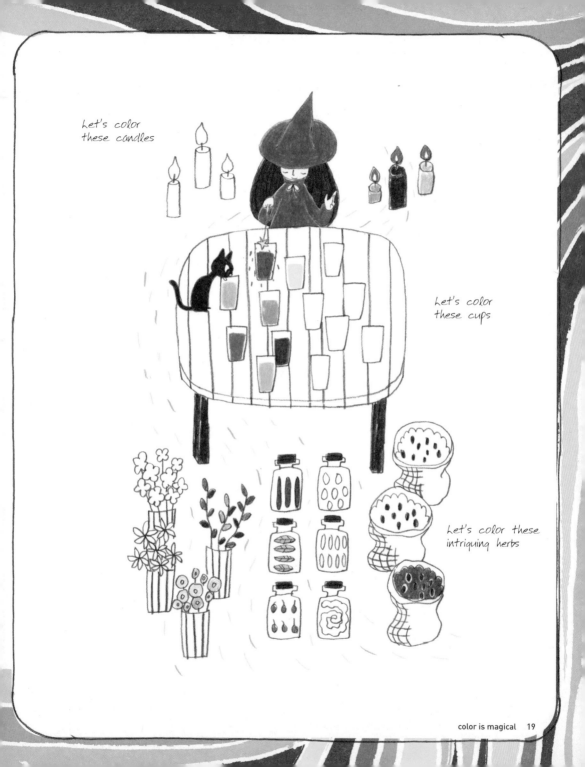

Let's color
these candles

Let's color
these cups

Let's color these
intriguing herbs

 everyone's face

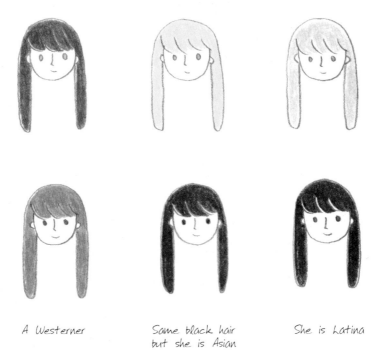

A Westerner

Same black hair
but she is Asian

She is Latina

The earth that we live on has many beautiful colors. Of course, we are a part of those colors. Everyone has adorable colors in their eyes and hair. You can visualize the faces of people all over the world just by combining the colors of hair and eyes.

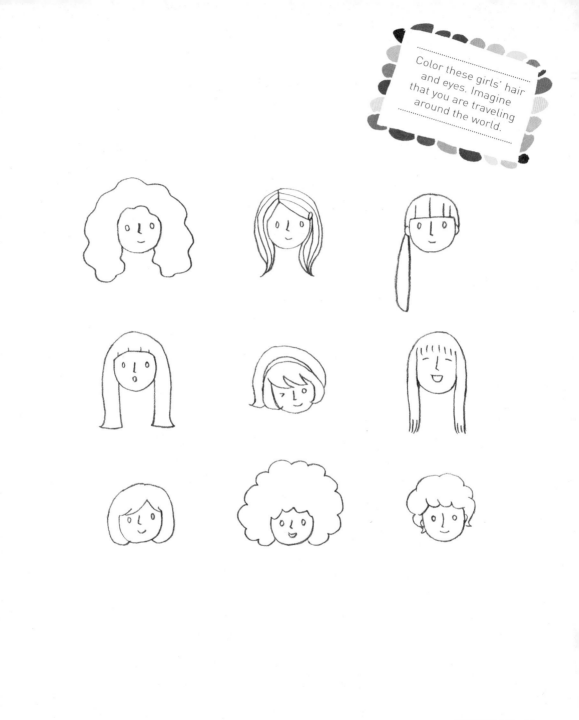

Color these girls' hair and eyes. Imagine that you are traveling around the world.

 favorite clothes

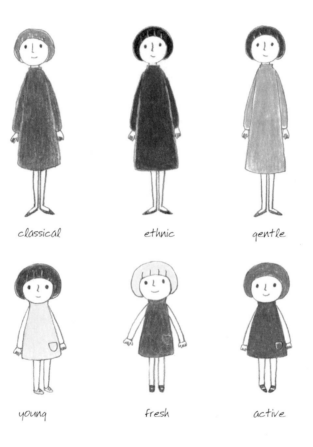

classical ethnic gentle

young fresh active

On a sheet of paper, it takes only a second to change one character's outfit to a different one.

Think about someone and use the colors as you like. You can try on as many clothes as you like and hold your own fashion show.

 new flowers

warm

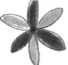

active

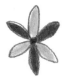

cool

young

strong

feminine

mature

elegant

pretty

calm

refreshing

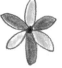

gentle

Do you know how many kinds of flowers there are in this world? There are flowers of all sorts of colors and shapes. We cannot even imagine the great many variations. It may even be infinite. I'm sure that there must be a flower that nobody has seen yet.

 intriguing animals

active

energetic

prim

pure

calm

boyish

precious

innocent

refreshing

steady

cool

loves to be pampered

Animals have many kinds of colors and patterns on them to hide their body or to threaten their enemies. On paper, it is OK to draw such animals as yellow elephants or pink zebras.

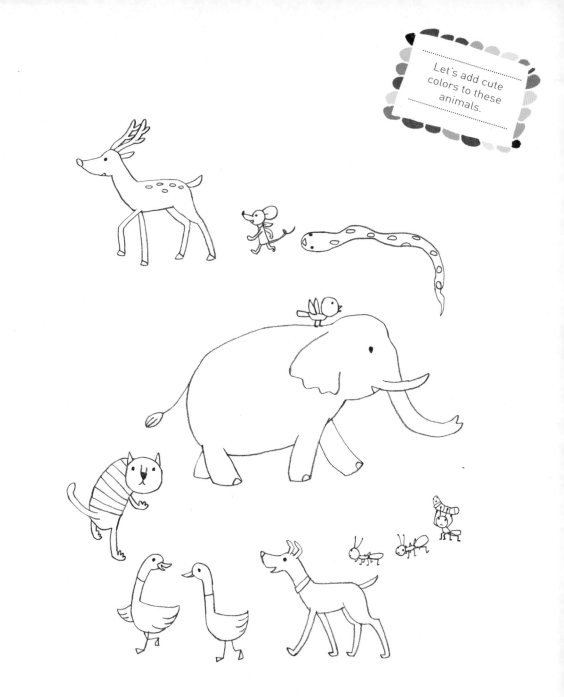

Let's add cute colors to these animals.

exciting vehicles

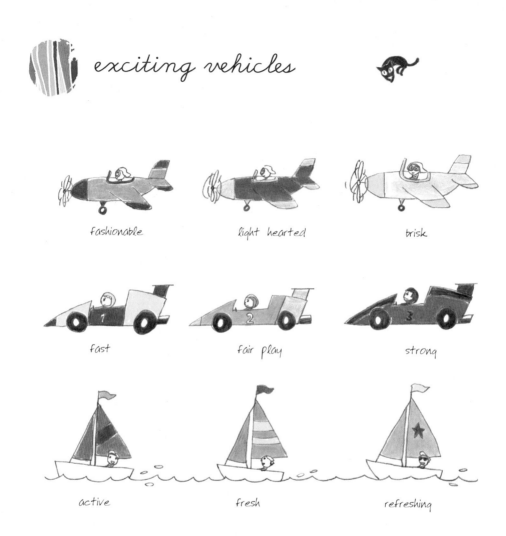

fashionable light hearted brisk

fast fair play strong

active fresh refreshing

Don't you feel excited when you are waiting in the line to ride a colorful Ferris wheel?
Don't you always look for your favorite color when looking at vehicles? Let's think about
cool, cute and fun-colored vehicles.

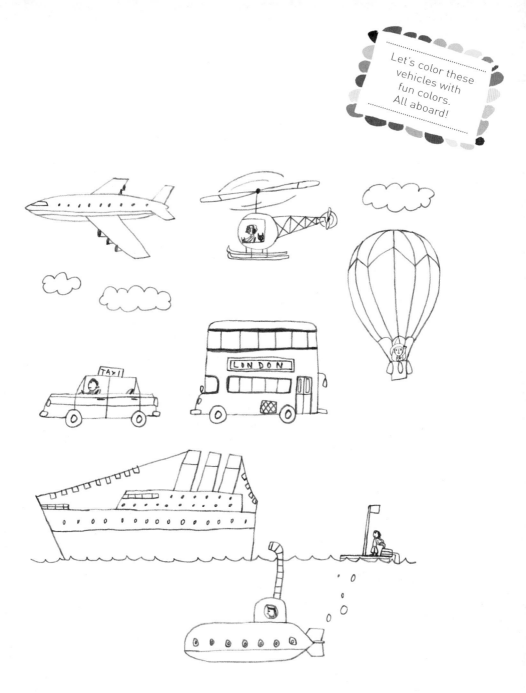

Let's color these vehicles with fun colors. All aboard!

LONDON

TAXI

 beautiful seasons

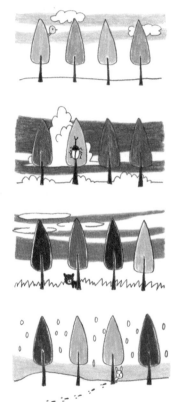

You can feel the transition from one season to the next not just by the change of the temperature, but also by the change of the colors. Spring colors make you feel excited, and autumn colors make you feel calm. The colors created by nature express the four seasons perfectly.

Shrill shrill.

I'm a cicada!

 dreamy castles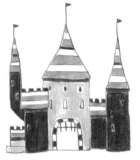

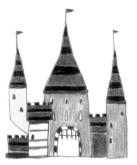

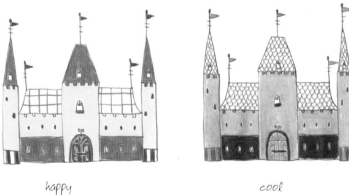

modern

cute

happy

cool

Viewing castles is captivating. What kind of kings and princesses were living inside these castles? What kind of colors were they surrounded by? Your imagination expands. It is also fun to imagine what kind of castle you want to live in.

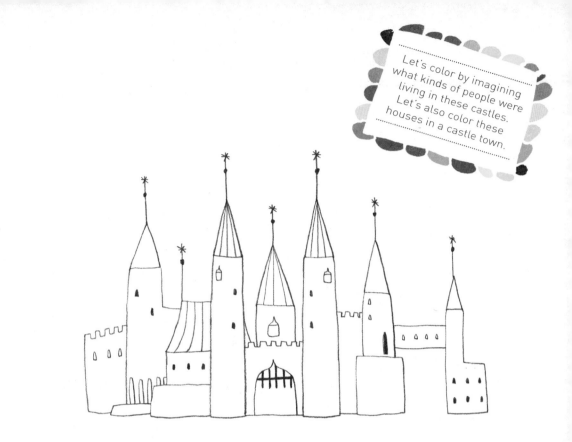

dark colors and faint colors

Even with the same color, the object looks different when looking at it in the dark or in the light.

This is because the object looks whitish when the light is bright, and it looks darkish when the light is not so bright. The range of expressions gets wider by coloring the same color in a different way.

There is a difference in how it looks when looking at things in a bright place or in a dark place.

Let's use the same color with a different brightness in one picture.

Sun burn

Red in the face

Three-dimensional

Difference between the flesh and the skin of fruit

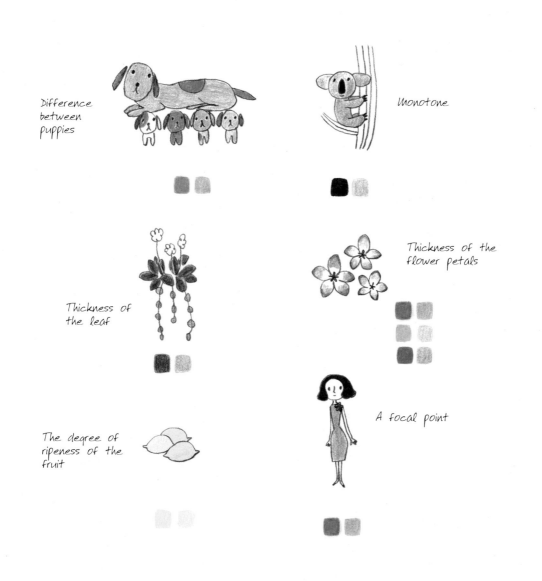

Difference between puppies

Monotone

Thickness of the leaf

Thickness of the flower petals

The degree of ripeness of the fruit

A focal point

CHAPTER 2
colors' feelings

What are
colors' feelings?

Red

Pink

Orange

Faint orange-yellow

Yellow

Light blue

Blue

Green

Yellow-green

Purple

Brown

Black

COLOUMN NO.2
Vivid colors and
austere elegant
colors

What are colors' feelings?

In this chapter, we will learn about colors' feelings.

Now, what are color's feelings?

Each color has its own impression and what people feel from it is somewhat the same.

For instance, don't you feel a sense of warmth from red or a sense of coolness from blue? You can feel healed by looking at green.

The character of each color, which inspires peoples' feelings, is what I call the colors' feelings.

Knowing these color's feelings will surely help you to express yourself.

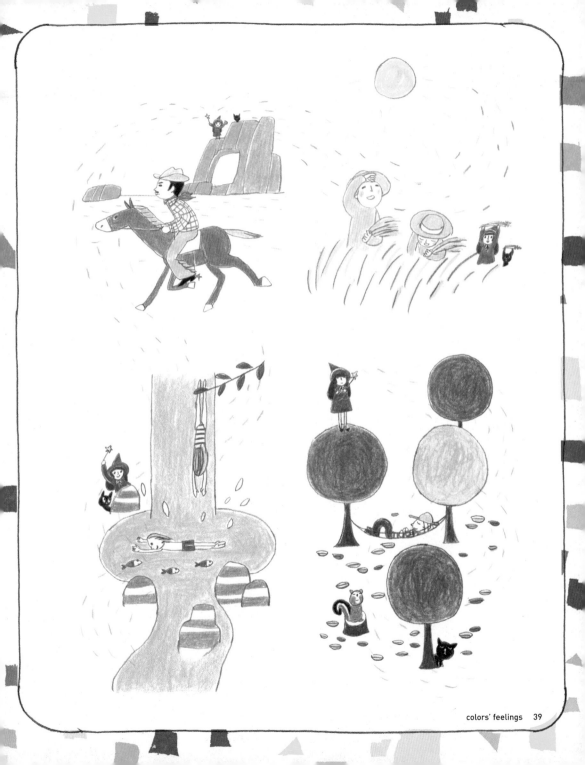

 red's feelings

Red is often used in happy events

It is also a color for hot things like chili peppers

A bowl of "Oseki-han" (red colored sticky rice mixed with azuki beans)

"Ko-haku manju" (red/white colored rice cakes stuffed with sweat bean paste)

A traditional Chinese lion

Red urges people to take precaution

Sale!

Red represents motivation

Red is a powerful color. I think you can be active and aggressive when you wear something red. We feel some kind of vital energy from red-colored things, such as mature fruits and plum-colored cheeks, don't we? In Japan and China, red is thought to be a lucky color. Moreover, deep red represents passion. Red wines and red dresses look mature. Red is said to be the most eye-catching color and it is often used to urge people to be precaucious.

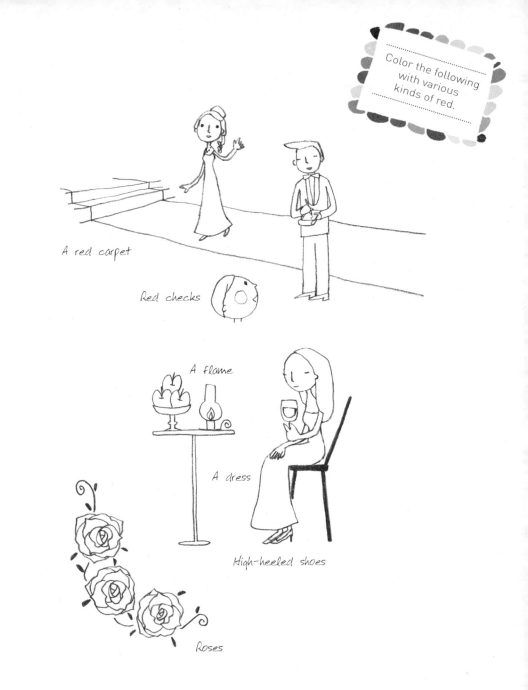

A red carpet

Red checks

A flame

A dress

High-heeled shoes

Roses

pink's feelings

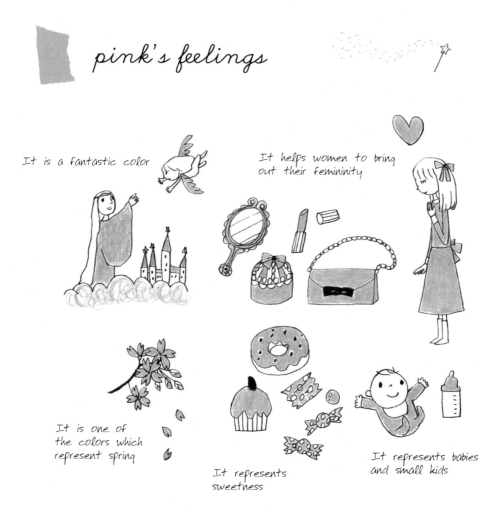

It is a fantastic color

It helps women to bring out their femininity

It is one of the colors which represent spring

It represents sweetness

It represents babies and small kids

Compared to red, pink is a more gentle and graceful color that always embraces our feelings. Don't you think that women look more feminine and men look more elegant in pink clothes? Pink is also a color that tells us of the arrival of spring. Pink carries a happy image for many people. Pink is also often used to express the world of fantasy.

A floral decoration

Pink flamingos

A rabbit

Strawberry doughnuts and strawberry cupcakes

Water lilies

orange's feelings

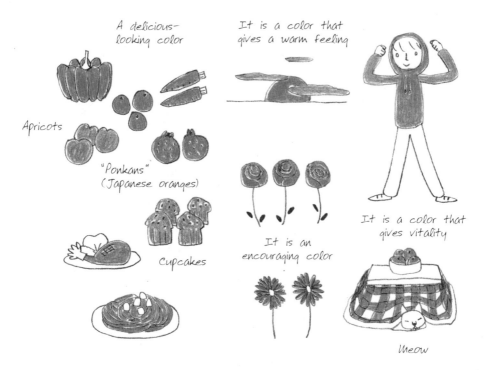

A delicious-looking color

It is a color that gives a warm feeling

Apricots

"Ponkans" (Japanese oranges)

Cupcakes

It is an encouraging color

It is a color that gives vitality

Meow

Orange is the color of sunshine's blessing. It is a color full of life that gives you power. You can often find fruits and vegetables that are this color, which means that orange-colored foods increase your appetite. It is also a color that gives you a sense of warmth. It appears that your sensory temperture increases a bit when you are surrounded by orange-colored things. In addition, orange makes people happy because it is a combination of two colors, aggressive red and cheerful yellow. All things said, orange is an eye-catching and assertive color.

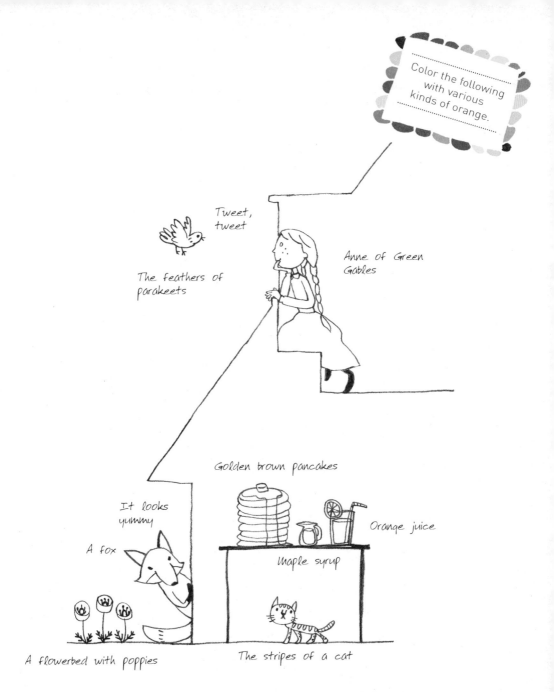

Color the following with various kinds of orange.

Tweet, tweet

The feathers of parakeets

Anne of Green Gables

Golden brown pancakes

It looks yummy

A fox

Orange juice

Maple syrup

A flowerbed with poppies

The stripes of a cat

faint orange-yellow's feelings

It is good to use this color on something fluffy

Foods of this color make you feel comfortable

Cookies

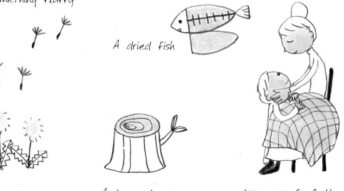

A dried fish

It is a color of natural materials

A tree stump

You can feel the warmth of human skin

This color mixed with orange and lots of white makes us think of delicious-looking bread and biscuits, or steaming hot milk tea and soup. It is a color that reflects a relaxing, home warmth. I think this color can make anybody and everybody feel warm. Faint orange-yellow makes us imagine fluffy and soft, natural materials. I think this color is suitable for sheep wool and dandelion puff.

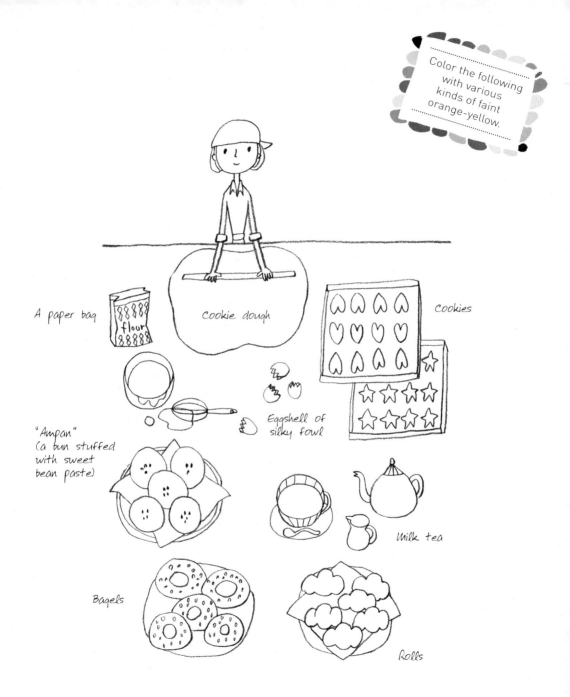

Color the following
with various
kinds of faint
orange-yellow.

A paper bag

Cookie dough

Cookies

"Ampan"
(a bun stuffed
with sweet
bean paste)

Eggshell of
silky fowl

Milk tea

Bagels

Rolls

yellow's feelings

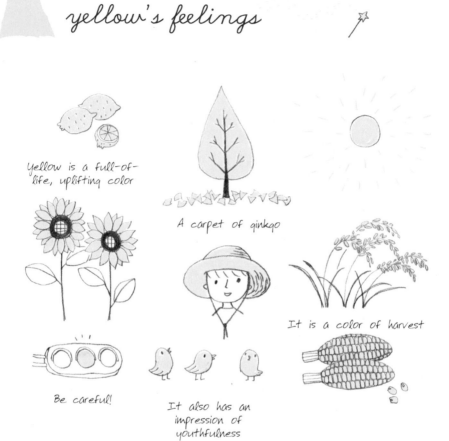

Yellow is a full-of-life, uplifting color

A carpet of ginkgo

It is a color of harvest

Be careful!

It also has an impression of youthfulness

Yellow is a bright color. It gives us the image of sunlight. It is a happy color that excites people and makes them happy. This color goes well with a dynamic and active atmosphere. It is often used to get peoples' attention, because it looks bigger than the actual painted area. An obvious example is construction-related signs.

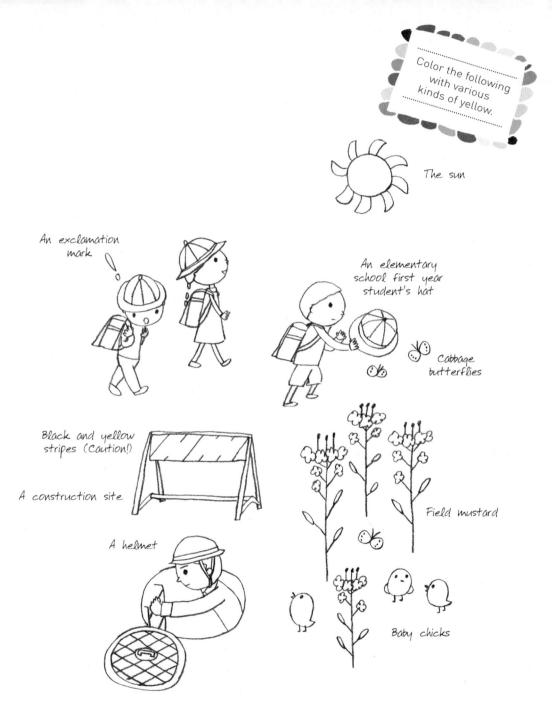

Color the following with various kinds of yellow.

The sun

An exclamation mark

An elementary school first year student's hat

Cabbage butterflies

Black and yellow stripes (Caution!)

A construction site

Field mustard

A helmet

Baby chicks

light blue's feelings

It is a refreshingly cool color

A bottle of cider

Fresh breeze

A fishbowl A wind-bell

CIDER

It represents cleanliness

So cold!

Light blue is a refreshing and relaxing color. It is also called "sky blue." In Japanese, light blue is called "mizu iro" which means "water color." As this name suggests, light blue has the image of water and sky which are generally considered to be a source of life. That is why this color brings comfort to us. It is said that this color has an effect of lowering our sensory temperature. We can see this color everywhere during the summer.

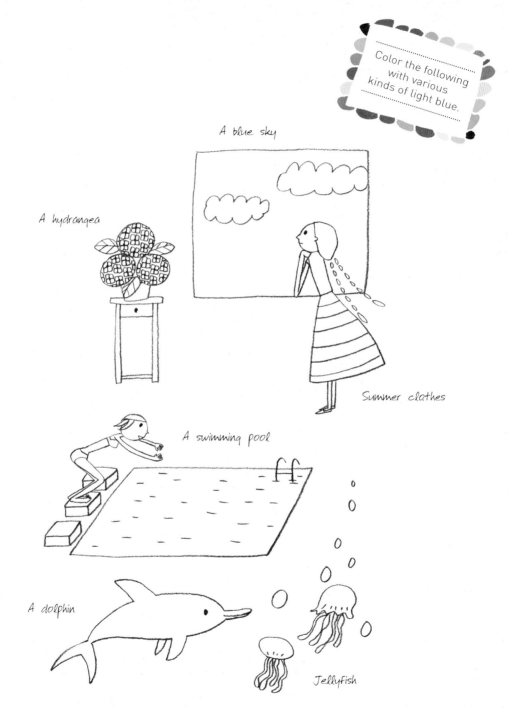

Color the following with various kinds of light blue.

A blue sky

A hydrangea

Summer clothes

A swimming pool

A dolphin

Jellyfish

blue's feelings

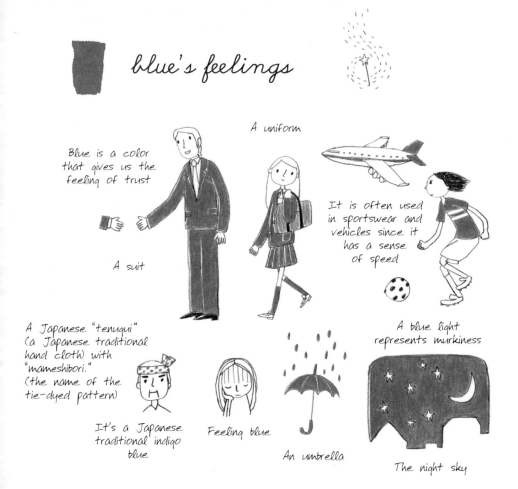

Blue is a color that gives us the feeling of trust

A suit

A uniform

It is often used in sportswear and vehicles since it has a sense of speed

A Japanese "tenugui" (a Japanese traditional hand cloth) with "mameshibori." (the name of the tie-dyed pattern)

It's a Japanese traditional indigo blue

Feeling blue

An umbrella

A blue light represents murkiness

The night sky

The color of the deep blue sea gives us a feeling of coolness and calmness. Many people get an intellectual image or a sense of integrity and trust from this color. In fact, blue-colored things have the psychological effect of suppressing our brain's excitation. Maybe this is why blue foods are not appetizing. Blue is the symbol color of the Blessed Virgin Mary and is also thought to be the symbol of innocence. Also, as we sometimes say "I'm feeling blue," it is used to express the feeling of disappointment.

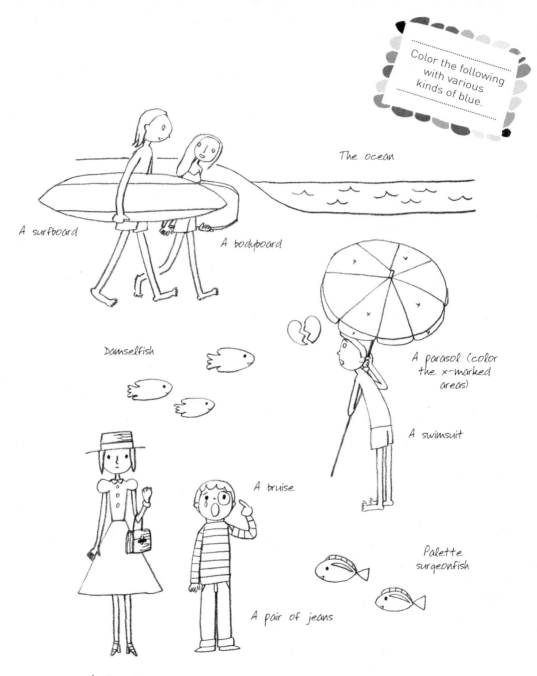

A surfboard

A bodyboard

The ocean

Damselfish

A parasol (color the x-marked areas)

A swimsuit

A bruise

Palette surgeonfish

A pair of jeans

A blue dress

green's feelings

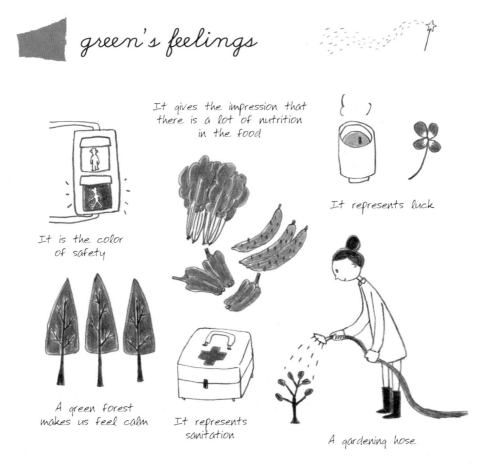

It gives the impression that there is a lot of nutrition in the food

It represents luck

It is the color of safety

A green forest makes us feel calm

It represents sanitation

A gardening hose

The word "midori" (green) was originally the word to describe vegetation. As in, we feel calm when we are in the forest, looking at green things is effective in comforting our mind. Also, green has the power to provide us with freshness and harmoniousness. Green is also easy on our eyes, and we usually don't get tired looking at green for a long time. (For this reason, the color of blackboards in schools was changed to green.) Green is regarded as the color of safety. It is also used in the emergency (first aid) logos, emergency exit signs and in traffic lights.

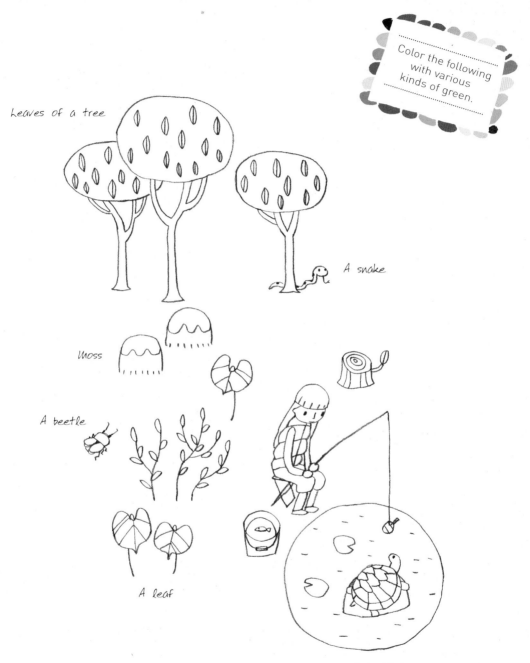

Leaves of a tree

Color the following with various kinds of green.

A snake

Moss

A beetle

A leaf

A turtle

light green's feelings

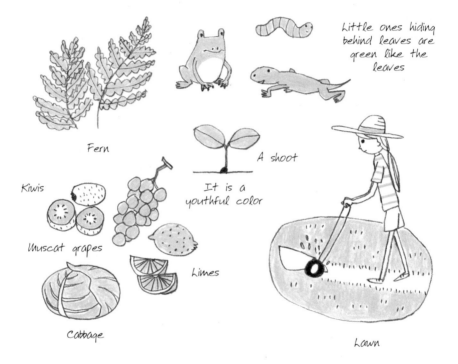

Fern

Little ones hiding behind leaves are green like the leaves

A shoot

It is a youthful color

Kiwis

Muscat grapes

Limes

Cabbage

Lawn

Light green is resembles the color of plant stems.

It is a color that refreshes our feelings. Also, it gives us the image of vitality and regeneration.

Much like green, light green is the color of nature, but it has a more refreshing impression. Light green is also a symbol of young leaves, which represents newborn purity and a sense of hope that something new is going to happen.

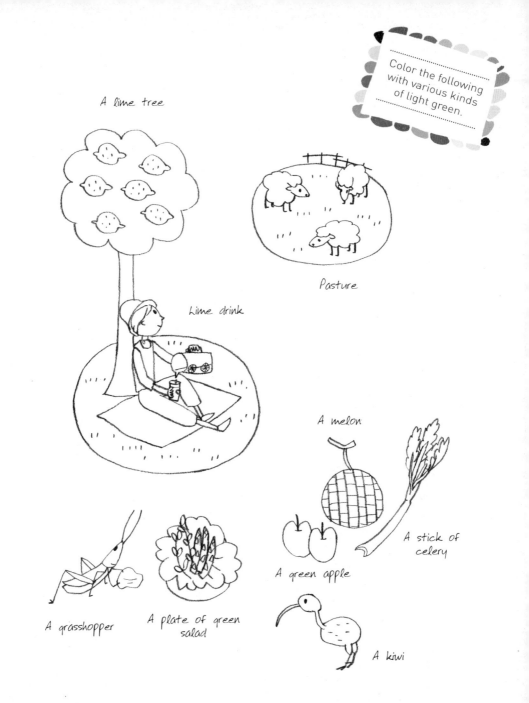

A lime tree

Color the following with various kinds of light green.

Pasture

Lime drink

A melon

A stick of celery

A green apple

A grasshopper

A plate of green salad

A kiwi

 purple's feelings

"Twelve level positions" (The first system in Japan to rank officials into twelve levels)

It is a color that meets the old Japanese requirements, such as elegance and moral tone

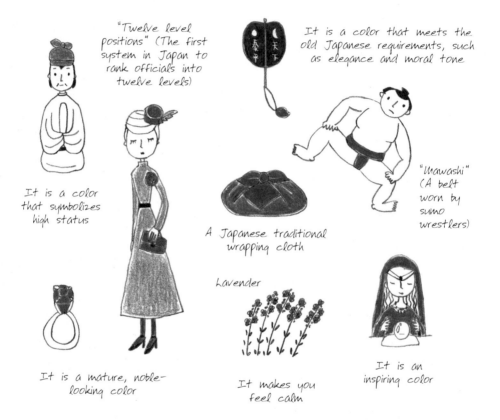

It is a color that symbolizes high status

"Mawashi" (A belt worn by sumo wrestlers)

A Japanese traditional wrapping cloth

Lavender

It is a mature, noble-looking color

It makes you feel calm

It is an inspiring color

Purple is said to be a mysterious color. The brilliant collaboration of red and blue brings about a passion and coolness as these colors live together in one color. Since early times, it has been regarded as a noble color in various parts of the world. That is because purple-colored ingredients were very valuable. Most people get a high-class and artistic impression from this color. Incidentally, Japan's national butterfly is called "Oomurasaki" (the giant purple.)

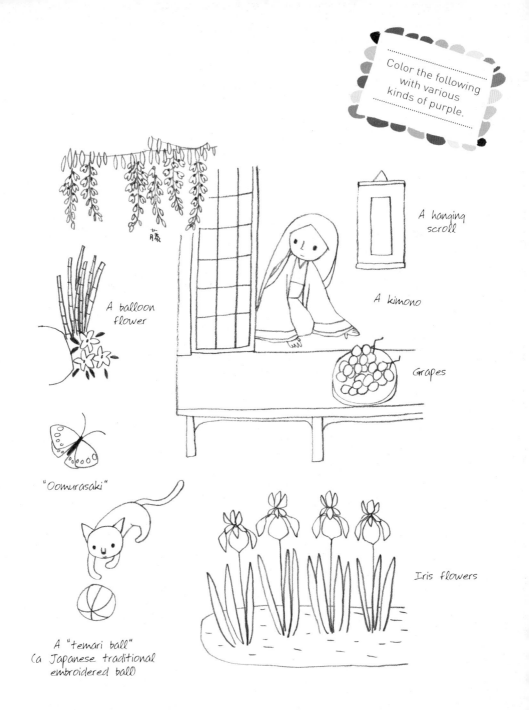

Color the following with various kinds of purple.

藤

A hanging scroll

A balloon flower

A kimono

Grapes

"Oomurasaki"

A "temari ball" (a Japanese traditional embroidered ball)

Iris flowers

brown's feelings

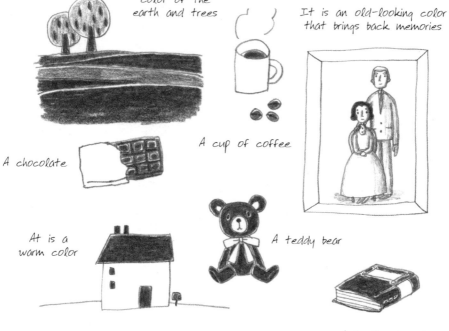

Brown is the color of the earth and trees

It is an old-looking color that brings back memories

A cup of coffee

A chocolate

At is a warm color

A teddy bear

A leather-bound book

Long ago, people used to brew tea leaves to collect this color, so this color in Japanese is called "cha-iro." (the word "cha" means tea, and "iro" means color)

It is a color that makes us think of nature, such as soil and trees. It gives us a calm, gentle feeling. It is also a color that calls up the sweetness of chocolate or the deep taste and the bitterness of coffee. Dark brown is called sepia. This color is often used to symbolize the color of old pictures and sweet memories of the past. In addition, brown is considered a color that doesn't spoil the view like white, gray and black.

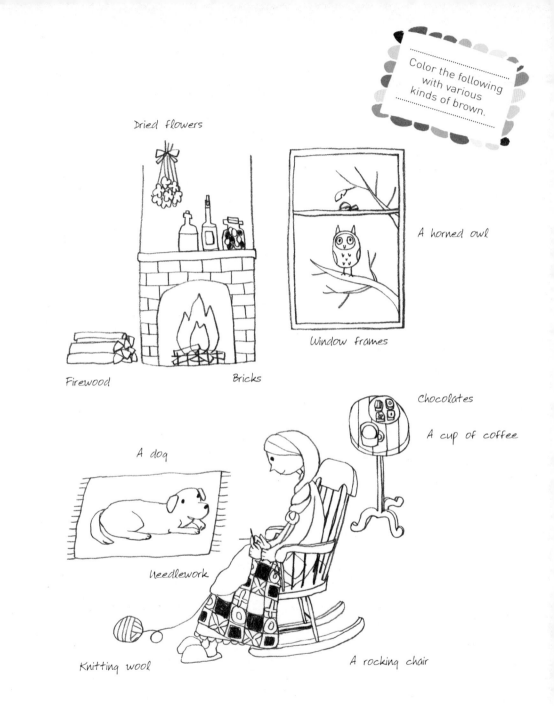

Dried flowers

A horned owl

Window frames

Firewood

Bricks

Chocolates

A cup of coffee

A dog

Needlework

Knitting wool

A rocking chair

 black's feeling

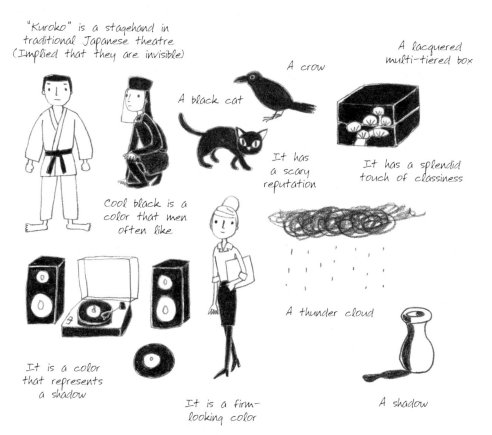

"Kuroko" is a stagehand in traditional Japanese theatre (Implied that they are invisible)

A crow

A lacquered multi-tiered box

A black cat

Cool black is a color that men often like

It has a scary reputation

It has a splendid touch of classiness

It is a color that represents a shadow

A thunder cloud

It is a firm-looking color

A shadow

Black is the color of no light. It is a color from the world of night which reflects quietness and anxiousness. It is also used to erase the sense of existence as in the case of "kuroko" in kabuki. Moreover, black is the color that gives us the impression of heaviness and hardness. That means it pairs perfectly with something or somebody authoritative and in formal situations. It is a color that combines decency and dignity.

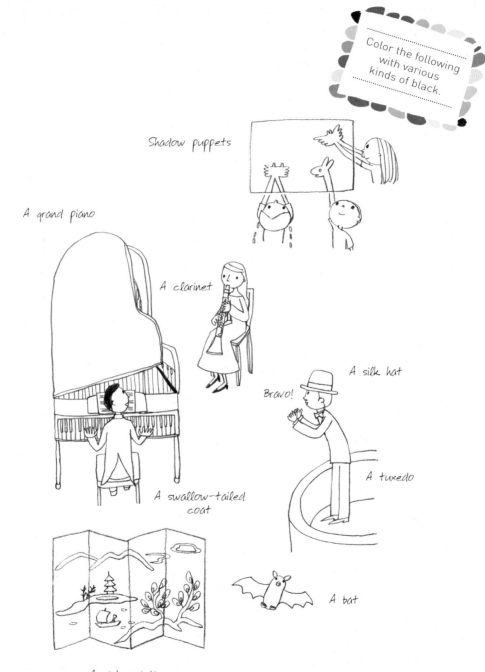

Color the following with various kinds of black.

Shadow puppets

A grand piano

A clarinet

A silk hat

Bravo!

A swallow-tailed coat

A tuxedo

An ink painting

A bat

vivid colors and austere elegant colors

Vivid colors match well with an active child. Austere elegant colors match well with a grown woman. Try using these colors with this perception in mind. By picking out colors with the same brightness, you will be able to make a picture that is clear.

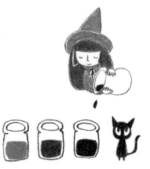

Let's use austere elegant colors mixed with black and grey.

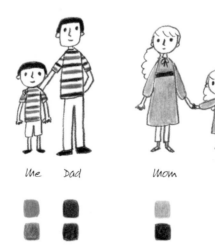

Me Dad Mom Me

A blue sky

A cloudy sky

A flower in a
southern country

A flower in a
high mountain

A melon

A cup of green tea

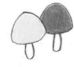

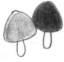

Which mushroom is edible?

CHAPTER 3
colors' messages

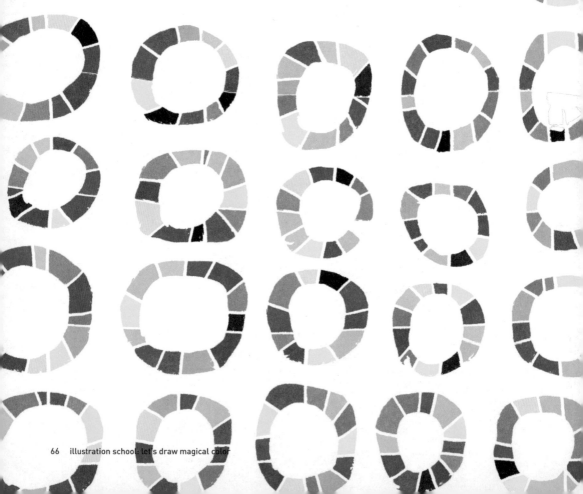

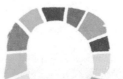

What is a
color's
message?

Cute

Fun

Active

Tasty

Cool

Strong

Mature

Warm

Cold

A happy occasion

Flashy

Gentle

COLUMN NO 3.
Mixing
Colors

What is a color's message?

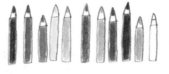

If you combine two or more colors to-
gether, the image of the colors reverber-
ates. Let's learn about the messages
created by the combined colors in this
chapter. First, take a look at the illus-
tration of colored pencils. Neighboring
colors are similar to each other. Colors
far apart are not similar. When two simi-
lar colors are combined together, they
support each other and deliver a united
message. When two different colors are
combined together, they emphasize each
other's character. The impression of the
illustration differs greatly when the per-
centage of the two colors' painted areas
are changed.

Quantity of
two colors

Quantity of
two colors

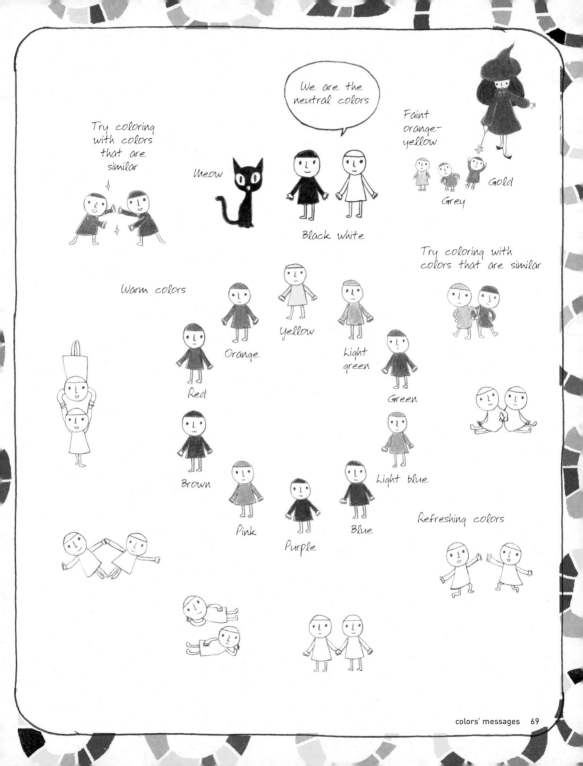

Try coloring
with colors
that are
similar

Meow

We are the
neutral colors

Faint
orange-
yellow

Gold

Grey

Black white

Try coloring with
colors that are similar

Warm colors

Yellow

Orange

Light
green

Red

Green

Brown

Light blue

Pink

Blue

Refreshing colors

Purple

colors' messages 69

a "cute" message

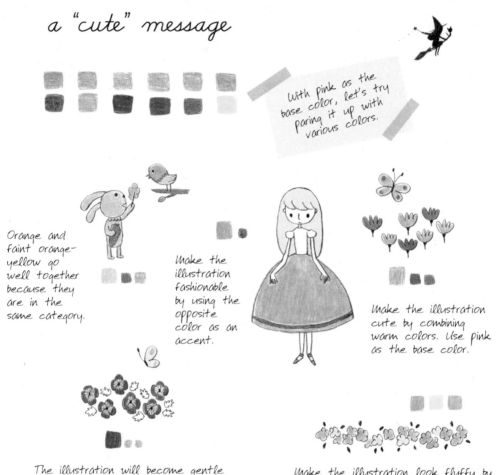

With pink as the base color, let's try paring it up with various colors.

Orange and faint orange-yellow go well together because they are in the same category.

Make the illustration fashionable by using the opposite color as an accent.

Make the illustration cute by combining warm colors. Use pink as the base color.

The illustration will become gentle and soft by putting pink or light blue inside a dark color.

Make the illustration look fluffy by using the same portion of colors that have the same tone.

What kind of feeling is required to make a cute coloration? Let's put our feelings into the color. It can be any kind of feeling, such as feeling of softness, sweetness, happiness, naivety or it can be a feeling of love. I use pink most of the time in my illustrations when I want to deliver a cute image. Pink has a soft impression. When you use pink as the main color, it influences other colors and they mysteriously start to look soft and gentle.

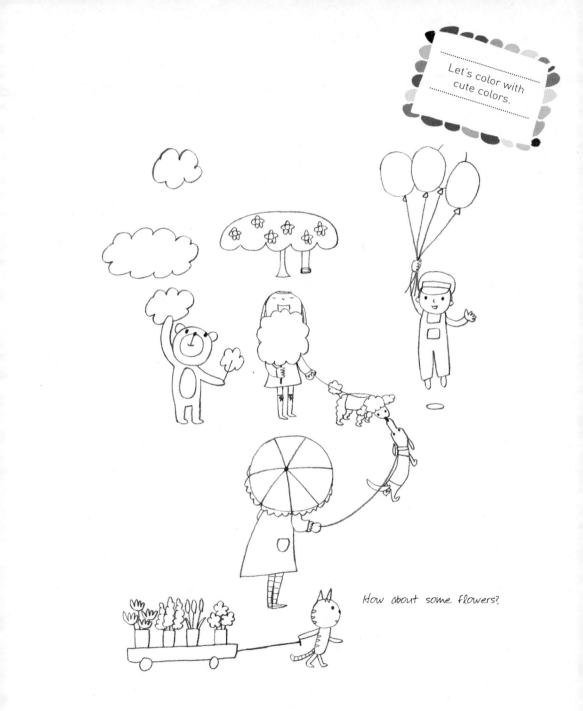

Let's color with
cute colors.

How about some flowers?

a "fun" message

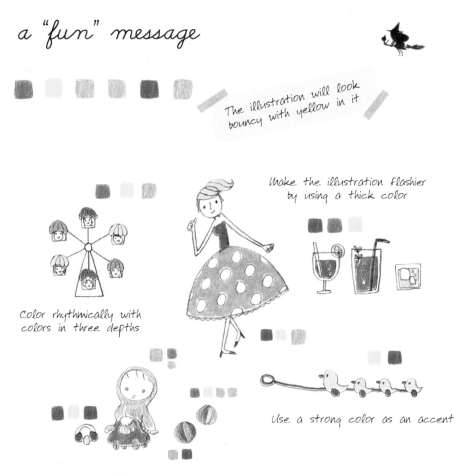

The illustration will look bouncy with yellow in it

Make the illustration flashier by using a thick color

Color rhythmically with colors in three depths

Use a strong color as an accent

Combine colors that are not similar so that the illustration looks colorful

A joyous coloration is made by a bright and cheerful collaboration of two or more colors. Use colorful and warm colors rhythmically. It is also good to remember that cold colors such as light blue, can be used upon warm colors so that it becomes an accent to express warmth.

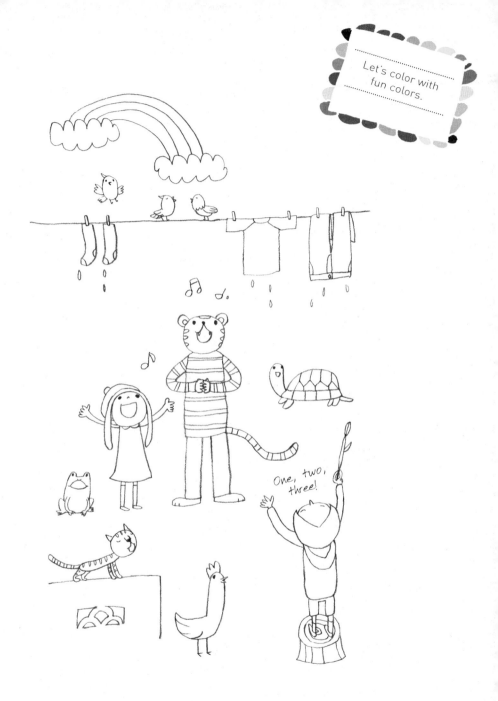

Let's color with fun colors.

One, two, three!

an "active" message

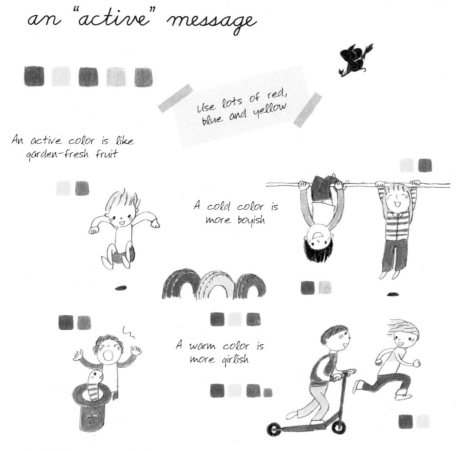

Use lots of red, blue and yellow

An active color is like garden-fresh fruit

A cold color is more boyish

A warm color is more girlish

Beside blue, orange looks more mild than red

The illustration looks powerful when the same amount of blue, red and yellow are used

Don't you become more cheerful when you see children playing with all their might? There's a strong message inside active colors that makes you feel good just by looking at them. It is important to combine energetic and uplifting colors that are just like active children. Try to use recognizable colors together, for example, red, blue, yellow, and green.

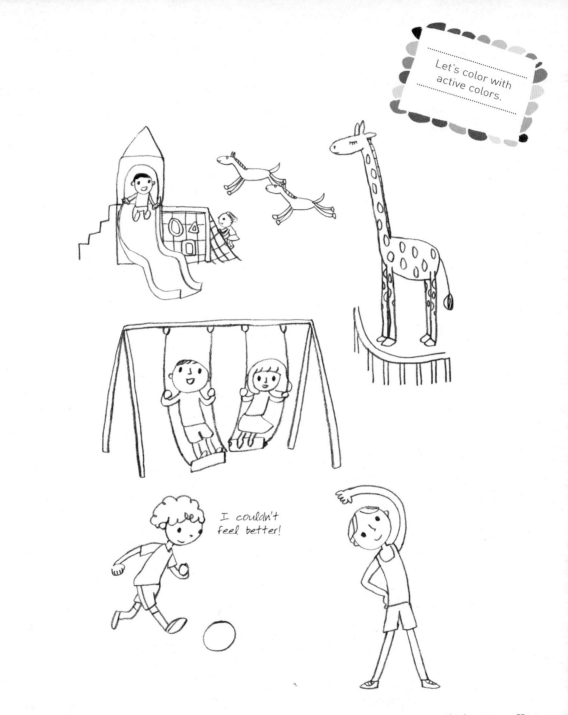

Let's color with active colors.

I couldn't feel better!

a "tasty" message

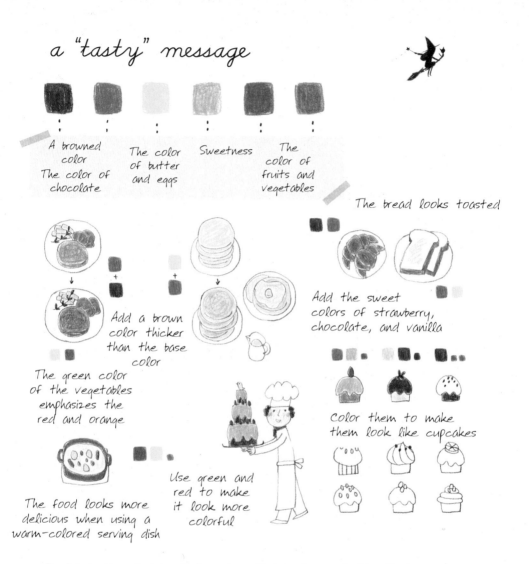

A browned color
The color of chocolate

The color of butter and eggs

Sweetness

The color of fruits and vegetables

The bread looks toasted

Add a brown color thicker than the base color

Add the sweet colors of strawberry, chocolate, and vanilla

The green color of the vegetables emphasizes the red and orange

Color them to make them look like cupcakes

The food looks more delicious when using a warm-colored serving dish

Use green and red to make it look more colorful

Fresh baked breads, juicy steaks, cakes with lots of cream inside... Don't you get hungry just imagining them? There are as many yummy-looking colors as there are yummy-looking foods.

Appetizing colors make us think of the colors of delicious foods. Yellow butter and red strawberry jam are especially appetizing. On the contrary, cold-looking colors close to blue are not appetizing and so we rarely see them in our daily foods.

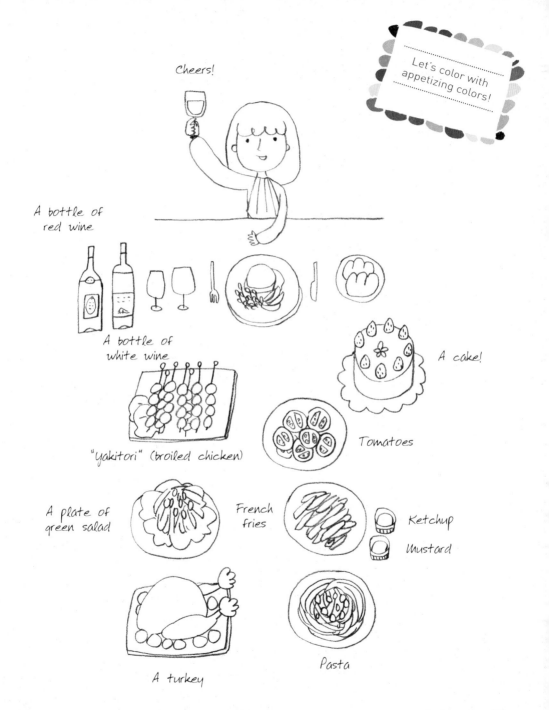

Cheers!

Let's color with appetizing colors!

A bottle of red wine

A bottle of white wine

A cake!

"yakitori" (broiled chicken)

Tomatoes

A plate of green salad

French fries

Ketchup

Mustard

A turkey

Pasta

a "cool" message

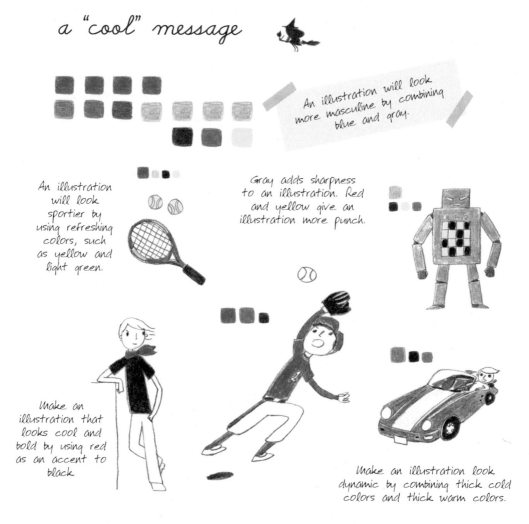

An illustration will look more masculine by combining blue and gray.

An illustration will look sportier by using refreshing colors, such as yellow and light green.

Gray adds sharpness to an illustration. Red and yellow give an illustration more punch.

Make an illustration that looks cool and bold by using red as an accent to black

Make an illustration look dynamic by combining thick cold colors and thick warm colors.

There is always a sense of speed and activeness, or a firm and discerning sharpness, in cool things. You can create a cool atmosphere by using blue as the main color, for it carries with it an elegance. Furthermore, it is good to use brave and passionate red or a high-quality and firm gray instead of blue so that you can create a different image of coolness.

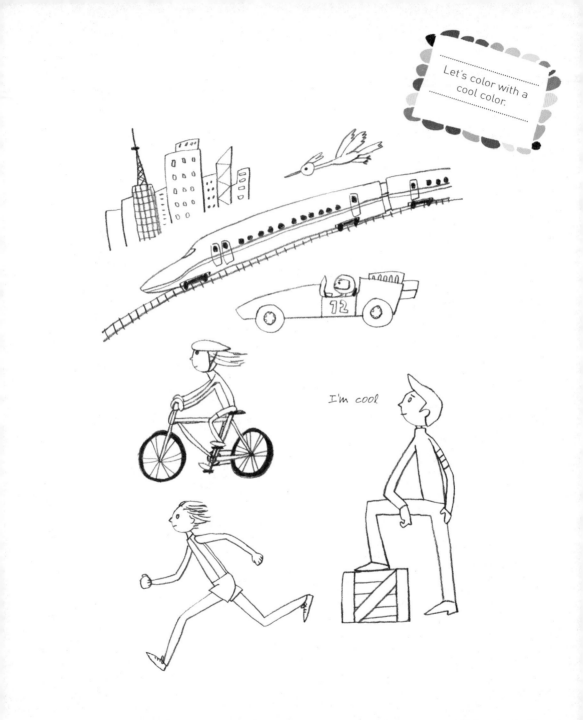

Let's color with a cool color.

I'm cool

a "strong" message

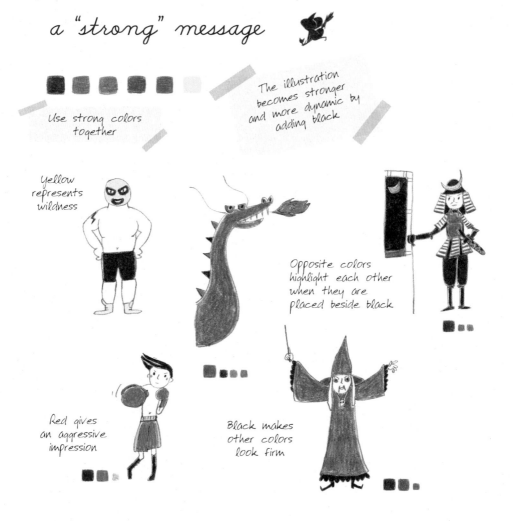

Use strong colors together

The illustration becomes stronger and more dynamic by adding black

Yellow represents wildness

Opposite colors highlight each other when they are placed beside black

Red gives an aggressive impression

Black makes other colors look firm

To deliver a strong impression, the coloration of the illustration must be very heavy. Let's set black as the main color and think about the coloring. Black itself is an intimidating color, but it influences other colors in a good way so that they start to emphasize their feelings strongly. For example, colors such as yellow and orange look fluffy beside pink and light blue, but they change their impression and become a strong color once they are used with black.

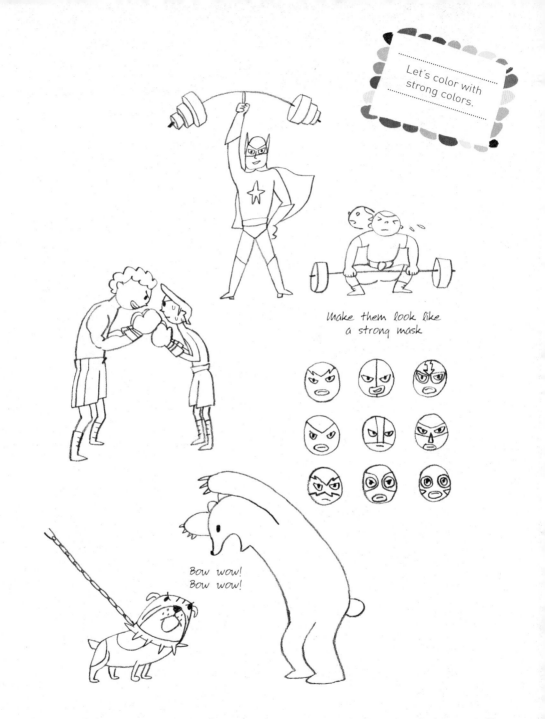

Let's color with strong colors.

Make them look like a strong mask

Bow wow!
Bow wow!

a "mature" message

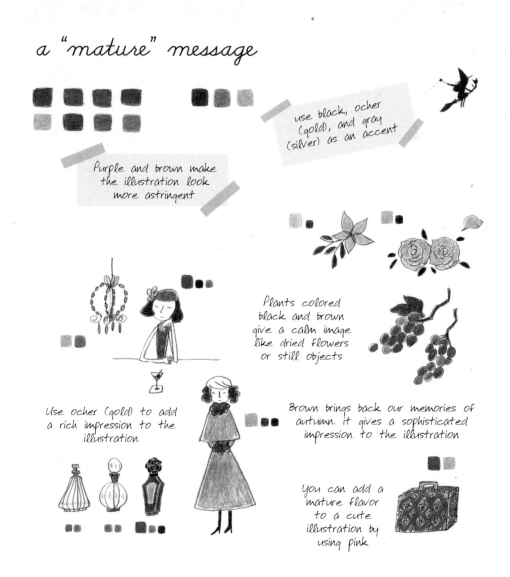

use black, ocher (gold), and gray (silver) as an accent

Purple and brown make the illustration look more astringent

Plants colored black and brown give a calm image like dried flowers or still objects

Use ocher (gold) to add a rich impression to the illustration

Brown brings back our memories of autumn. it gives a sophisticated impression to the illustration

You can add a mature flavor to a cute illustration by using pink

Let's think about a sophisticated, calm, and elegant coloration. How about using purple, which is elegant and mysterious, as the main color? Purple always embraces other colors gently. If you use calm colors such as blue, black and brown with purple, your illustration will become more elegant and mature. Colors such as gray (silver) and ocher (gold) can also provide a gorgeous accent.

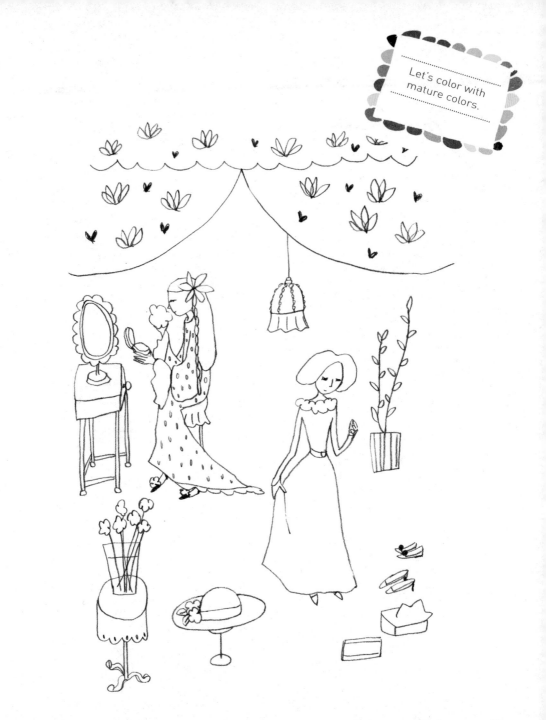

Let's color with mature colors.

a "warm" message

Add warm colors to the base color, brown and red

Use the same amount of red and brown to give a rich and deep flavor to the illustration

Green offers the warm impression of nature

Faint yellow-orange tones down the force of red, orange and black

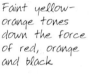

Use pink in your illustration to deliver a kind impression

Let's think about "warm" coloring that has a sense of comfort just like your mom's warm hands. Use brown as the main color rather than red because red seems hot. I think brown is a reassuring color because it is the color of Mother Nature. You can deliver a message of warmth by adding green, which makes us think of plants and grass.

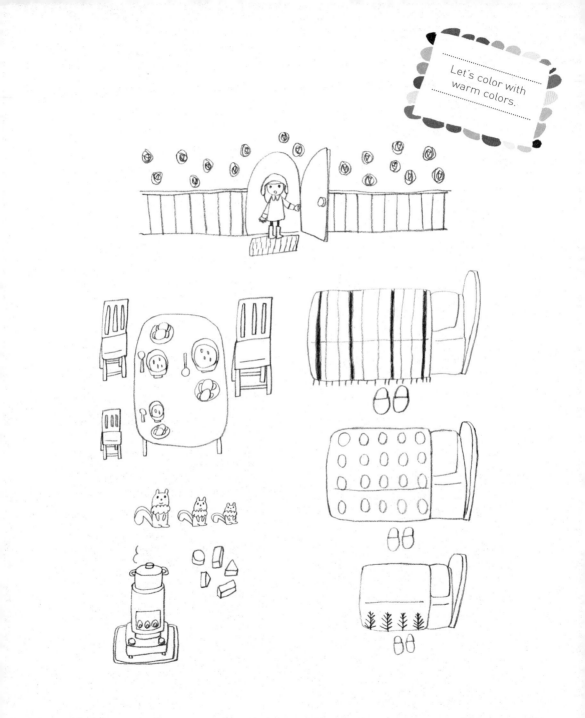

Let's color with warm colors.

a "cold" message

Blue and light blue represent coldness

You can give a breezy impression to your illustration by adding light blue.

Using white is one option. The impression of your illustration becomes cold because white is the color of snow and ice.

Add a cold impression to your illustration by using dark blue and dark green.

The illustration will look fresher if you add yellow and light green.

Colors like white and blue come to mind when we think of something cold. It is because we often associate these colors with ice and water. Most people feel a pleasant cool sensation from colors like white and blue. Let's use these colors as the main color and think about the coloration. You can deliver a message of coldness by using just these colors, but try adding colors such as yellow and green so that you can give a juicy, fresh element to your illustration.

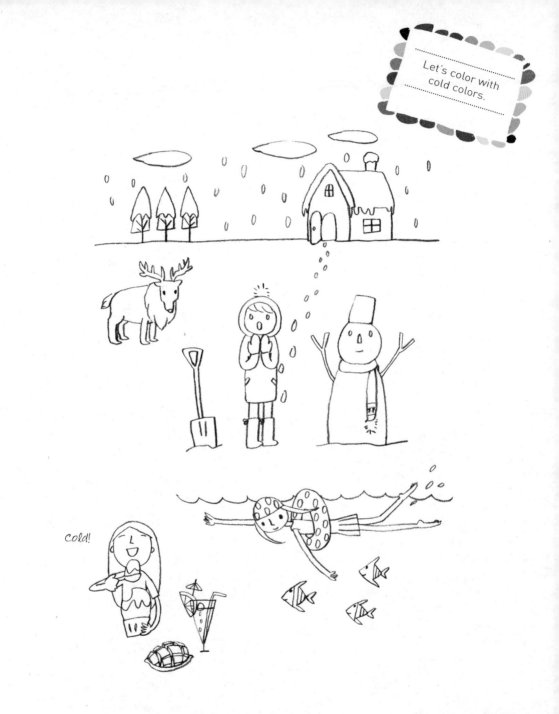

Let's color with cold colors.

Cold!

a "happy occasion" message

Use ocher and gray to resemble gold and silver

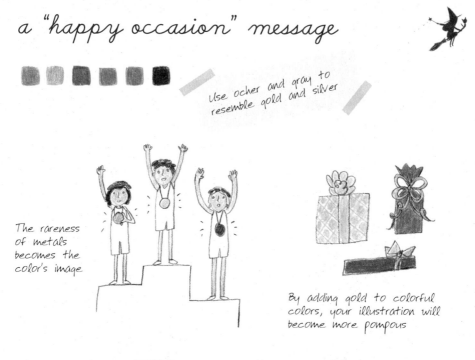

The rareness of metals becomes the color's image

By adding gold to colorful colors, your illustration will become more pompous

Red and white are traditional ceremonial colors in Japan

Don't you want to greet the arrival of holidays, such as New Year's Day, your birthday, and Christmas with special, unusual colors? Gold makes the illustration look gorgeous because it is literary the color of gold. Gold is also the color of rice ears and the sun. It is good to use yellow and ocher instead of gold if you don't have gold. Colors for celebration differ by country and festival. Wouldn't it be fun to search for such colors?

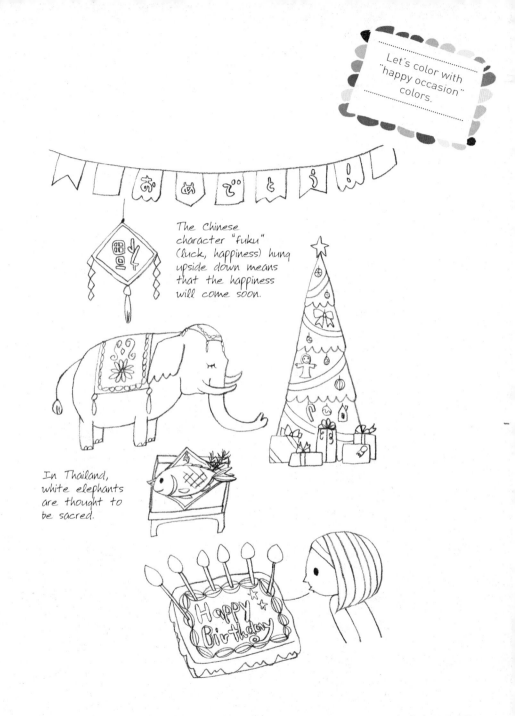

The Chinese character "fuku" (luck, happiness) hung upside down means that the happiness will come soon.

In Thailand, white elephants are thought to be sacred.

a "flashy" message

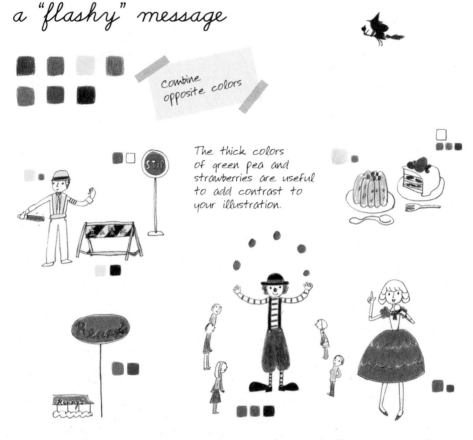

combine opposite colors

The thick colors of green pea and strawberries are useful to add contrast to your illustration.

The letters stand out when opposite colors are used.

Your character will stand out with strong-colored clothes on them.

It is effective to combine opposite colors when one wants to create an outstanding coloration. Such colorations can be the combination of red and green, blue and orange, yellow and purple, for instance. It is also effective to combine thin colors and thick colors. Moreover, the combination of red and yellow is often used in signs to draw everyone's attention. This coloration alarms people subliminally.

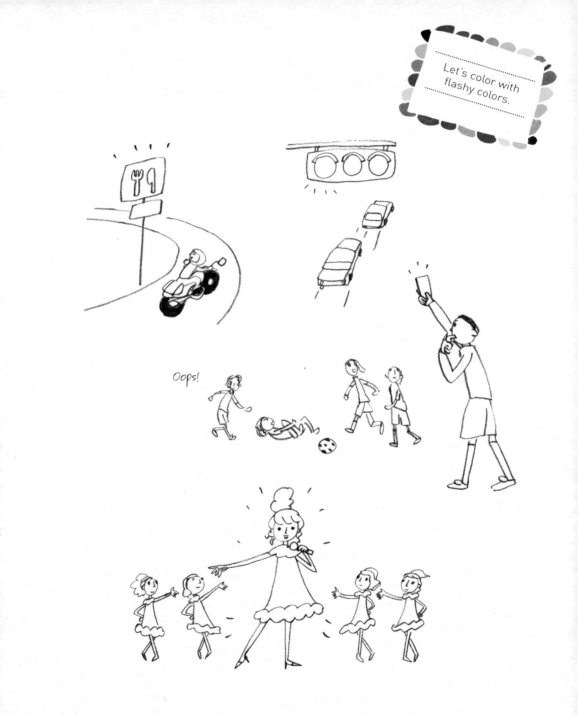

Let's color with flashy colors.

Oops!

a "gentle" message

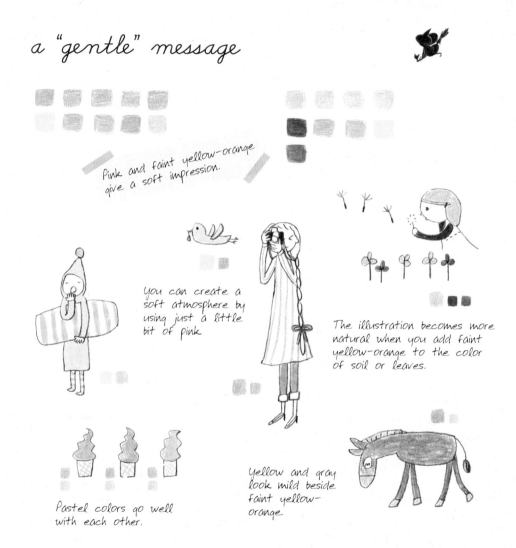

Pink and faint yellow-orange give a soft impression.

you can create a soft atmosphere by using just a little bit of pink

The illustration becomes more natural when you add faint yellow-orange to the color of soil or leaves.

Pastel colors go well with each other.

Yellow and gray look mild beside faint yellow-orange.

Search for combinations of colors that give the gentlest and the most humble impression. Unlike the combination of strong colors, it is good to combine fluffy faint colors together. Use pink or faint yellow-orange as the main color. The image of the illustration becomes more girlish when pink is used, and it becomes more natural when faint yellow-orange is used. Light blue and gray are also a good combination.

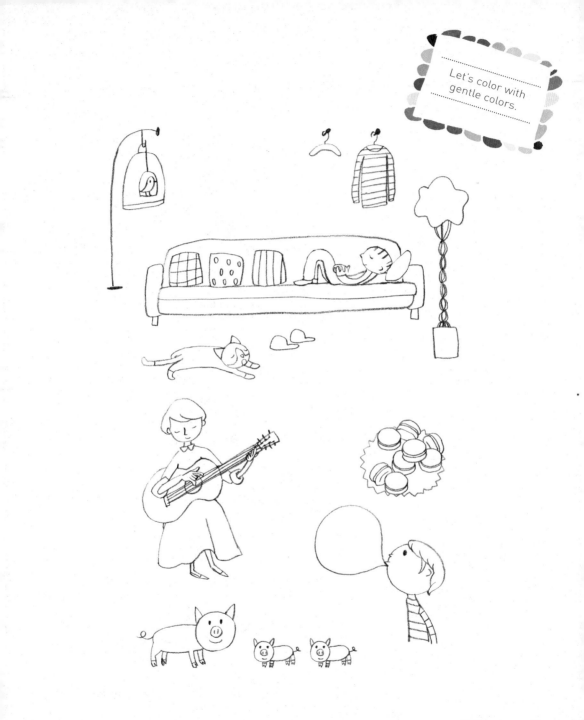

Let's color with gentle colors.

mixing colors

What kind of color can you create by mixing different colors? You can increase the number of colors you have by mixing colors. Let's mix colors you have and find the new colors! The result will change if you mix them in a reverse order.

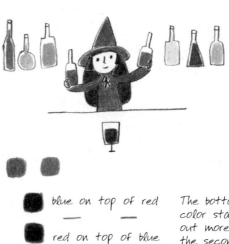

blue on top of red ____

red on top of blue ____

The bottom color stands out more than the second color

Bananas

Yellow based

A pizza

Green soybeans

Light-green based

A shoot

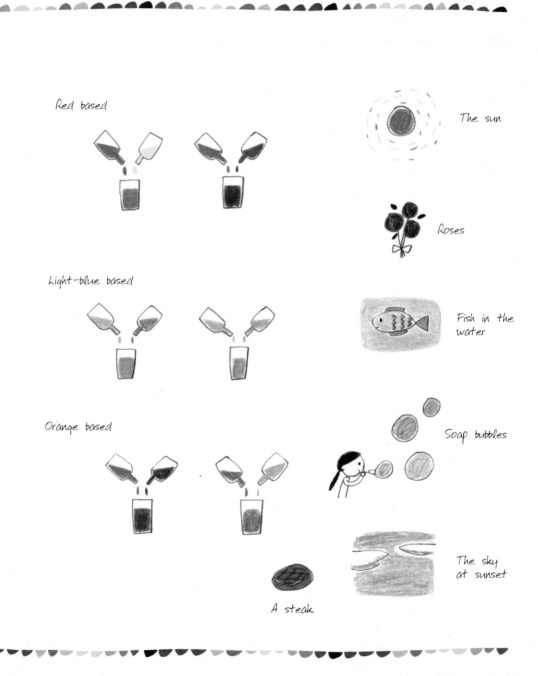

Red based

The sun

Roses

Light-blue based

Fish in the water

Orange based

Soap bubbles

A steak

The sky at sunset

EPILOGUE

Magical pictures for coloring

by Sachiko Umoto

How cute!

Hello!

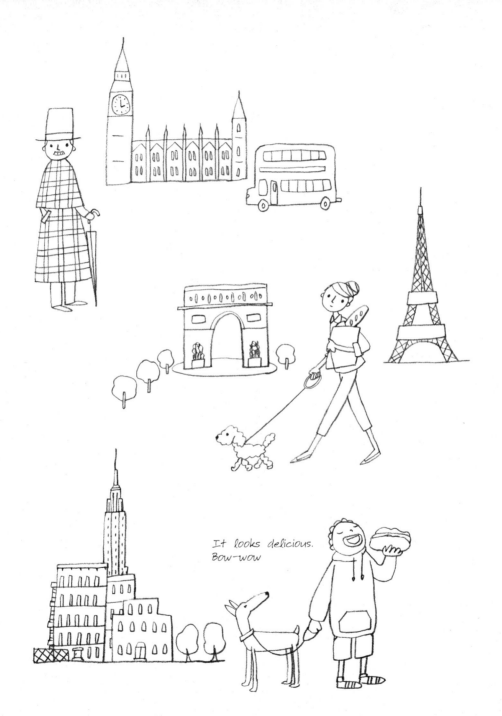

It looks delicious.
Bow-wow

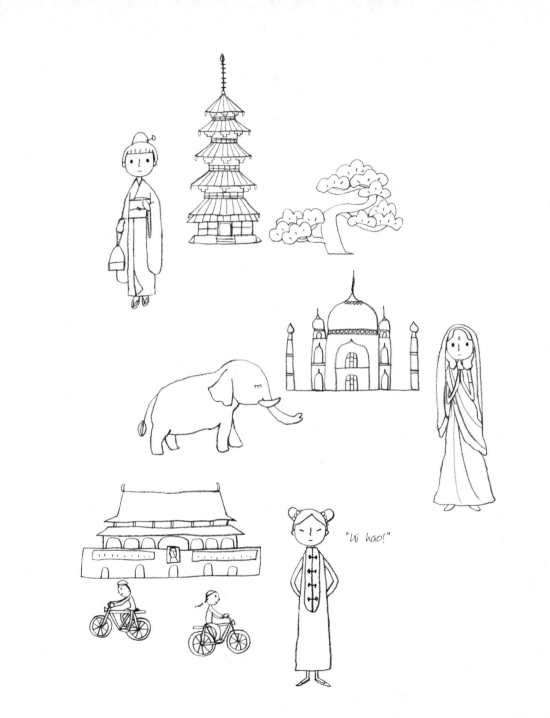

"Ni hao!"

I'm your grandma

bun

tomato

ketchup

olive

slice of cheese

bacon

fried egg

lettuce

tomato

hamburger

ham

bun

lettuce

onion

mustard

hamburger

smoked chicken

pineapple

pickles

hamburger

onion

lettuce

SODA

MILK

Jelly

honey

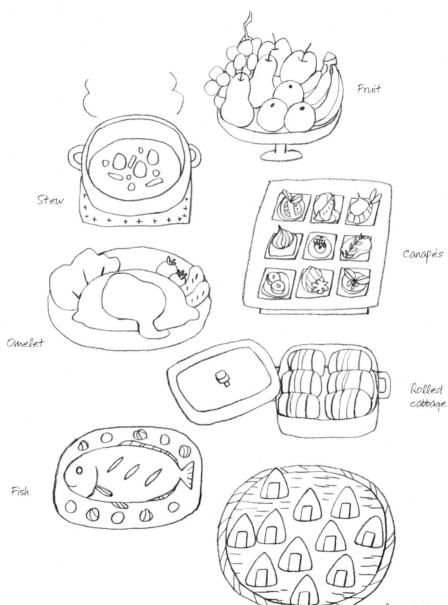

Fruit

Stew

Canapés

Omelet

Rolled cabbage

Fish

Rice balls

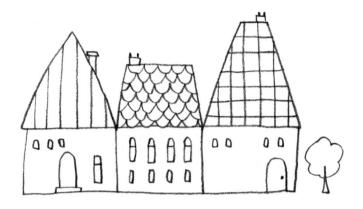

Meow,
meow

Relaxing

GOAL

Suspicious...

about the author

Sachiko Umoto, born in 1970, graduated with a degree in oil painting from Tama Art University (Tokyo). In addition to her work as an illustrator, she also produces animation works for Usagi-Ou Inc. She is the author of *Illustration School: Let's Draw Happy People, Let's Draw Cute Animals*, and *Let's Draw Plants and Small Creatures*; as well as *An Introduction to Making Illustrations with One Pencil Workbook* and *An Introduction to Sketching with One Pencil Workbook* (both published by MDN Corporation). She dearly loves dogs and Hawaii. Visit her online at http:// umotosachiko.com.